STOCK ART

SHUTTERSTOCK.COM: Collection of wine stains (pp. 1, 30, 92, 93) © Picsfive; vector bottles (pp. 4, 5) © Thirteen-fifty; hand-drawn backgrounds (pp. 6, 22, 42, 64, 86, 95, 100, 102, 110) © KhrobostovA; vintage-style labels (pp. 6, 68, 70, 71, 101) © mhatzapa; cartoon rabbit on plane, cartoon drinks, aluminum can top, and dinner plate (pp. 15, 83, 110) © dmiskv; tray of cocktails, beer mug, bottles, cake, anchor (pp. 22, 63, 64, 86, 98, 106) © Retroclipart; beer bottle (p. 42) © Doris Rich; vintage-style beer labels (p. 101) © Grafiksz

iSTOCK.COM: Set of four red wine stains (p. 1) © daneger; ornate line art frame, skull and banner, robot bird (pp. 12, 13, 14, 15) © artplay711; shot glass (p. 24) © Evgeny Karandaev; wine glass (p. 25) © ansonsaw; on the rocks (p. 26) © Alexey Lysenko; cup of coffee (p. 27) © Anatoly Tiplyashin; red wine stains (p. 28) © David Gunn; set of four red wine stains (pp. 28, 29, 31) © subjug; crazy brunette (p. 34) © charity myers; party animal (p. 35) © Jon Schulte; aluminum can top (pp. 36, 37) © Matt Craven; beer mug (p. 38) © Bjorn Heller; appletini (p. 39) © Eddie Berman; row of urinals (p. 40, 41) © Michael Westhoff; empty picture frame (pp. 50, 51) © 4x6; passed-out guy with glasses (p. 52) © Joel Sorrell; low blood pressure (p. 52) © piccerella; overdose (p. 52) © Mike Cherim; hand-drawn frames (pp. 52, 53) © Megan Tamaccio; fancy picture frame (p. 54) © 4x6; clear billboard (p. 66) © Olivier Blondeau; bus stop billboard (p. 67) © zoomstudio; new family room (p. 80, 81) © M. Eric Honeycutt; partying business man (p. 88) © Simone van den Berg; party at office (p. 88) © Aga & Miko Materne; drunk business woman (p. 89) © Sharon Dominick; funny drunk business man (p. 89) © Catalin Petolea; man with drinking glass silhouettes (p. 96) © Slobodan Djajic; party silhouettes (pp. 96, 97) © Leontura; drinking silhouettes (pp. 96, 97) © Slobodan Djajic; retro label (p. 118) © cajoer; bottle bottoms (p. 128) © Ruslan Dashinsky

ILLUSTRATIONS BY LANA LE: texting cell phone (p. 95)

ALL OTHER ILLUSTRATIONS BY MATT DAVIS
AND DANIELLE DESCHENES

DESIGN BY
DANIELLE DESCHENES

PUBLISHED IN THE UNITED STATES BY POTTER STYLE, AN IMPRINT OF THE CROWN PUBLISHING GROUP, A DIVISION OF RANDOM HOUSE, INC., NEW YORK.

WWW.CLARKSONPOTTER.COM
POTTER STYLE IS A TRADEMARK AND POTTER AND COLOPHON ARE REGISTERED TRADEMARKS OF RANDOM HOUSE, INC., NEW YORK.

ISBN: 978-0-307-88692-7

PRINTED IN CHINA

10 9 8 7 6 5 4 3 2

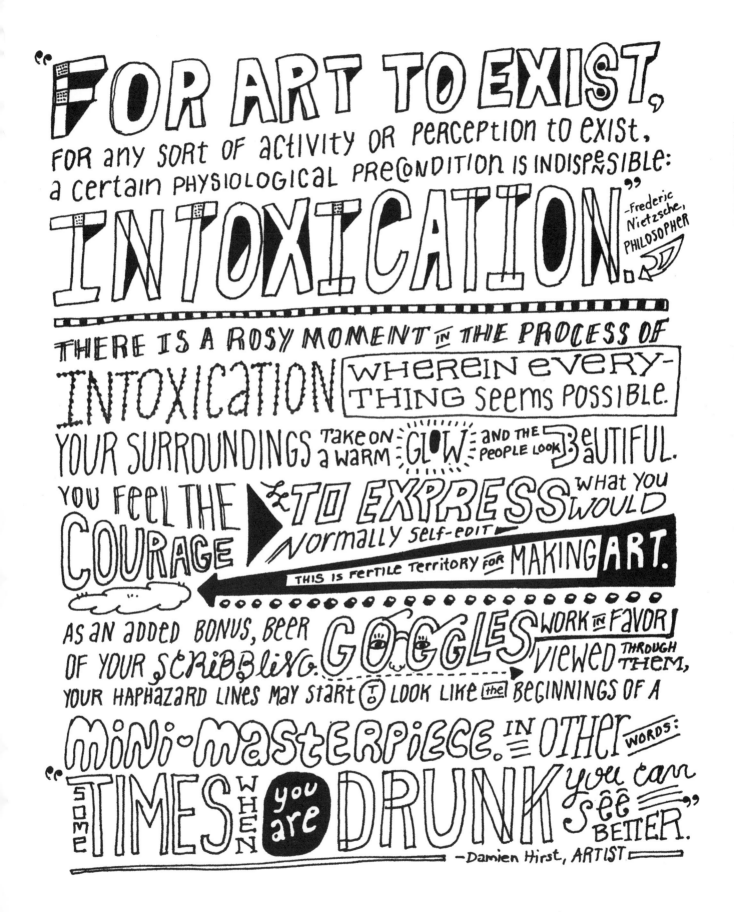

"FOR ART TO EXIST, FOR any SORT OF ACTIVITY OR PERCEPTION TO EXIST, A certain PHYSIOLOGICAL PRECONDITION IS INDISPESIBLE: INTOXICATION." —Frederic Nietzsche, PHILOSOPHER

THERE IS A ROSY MOMENT IN THE PROCESS OF INTOXICATION WHEREIN EVERY-THING SEEMS POSSIBLE. YOUR SURROUNDINGS TAKE ON A WARM GLOW AND THE PEOPLE LOOK BEUTIFUL. YOU FEEL THE COURAGE TO EXPRESS WHAT YOU WOULD NORMALLY SELF-EDIT. THIS IS FERTILE TERRITORY FOR MAKING ART.

AS AN ADDED BONUS, BEER GOGGLES WORK IN FAVOR OF YOUR SCRIBBLING. VIEWED THROUGH THEM, YOUR HAPHAZARD LINES MAY START TO LOOK LIKE THE BEGINNINGS OF A MINI-MASTERPIECE. IN OTHER WORDS: "SOMETIMES WHEN you are DRUNK you can see BETTER." —Damien Hirst, ARTIST

CONTENTS

4.
CREATIVE CAREERS
DRINKING ON THE JOB

5.
HAPPY HOUR~s~
GAMES TO PASS THE TIME ^

6.
DEEP THOUGHTS
DRUNK MUSINGS, HALF-REMEMBERED

COLOR INSIDE THE LINES?

YOUR BASIC SKILLS, TRASHED

start date:

99 BOTTLES OF BEER

COLOR IN A BOTTLE EVERY TIME YOU HAVE A BEER. end date:
HOW LONG DOES IT TAKE YOU TO FILL THEM IN? _____

BONUS:
Drink
10
more

DRAW A STRAIGHT LINE

SOBER

Do this sober and again later when you are very, very drunk.

DRUNK

What I was drinking: _____

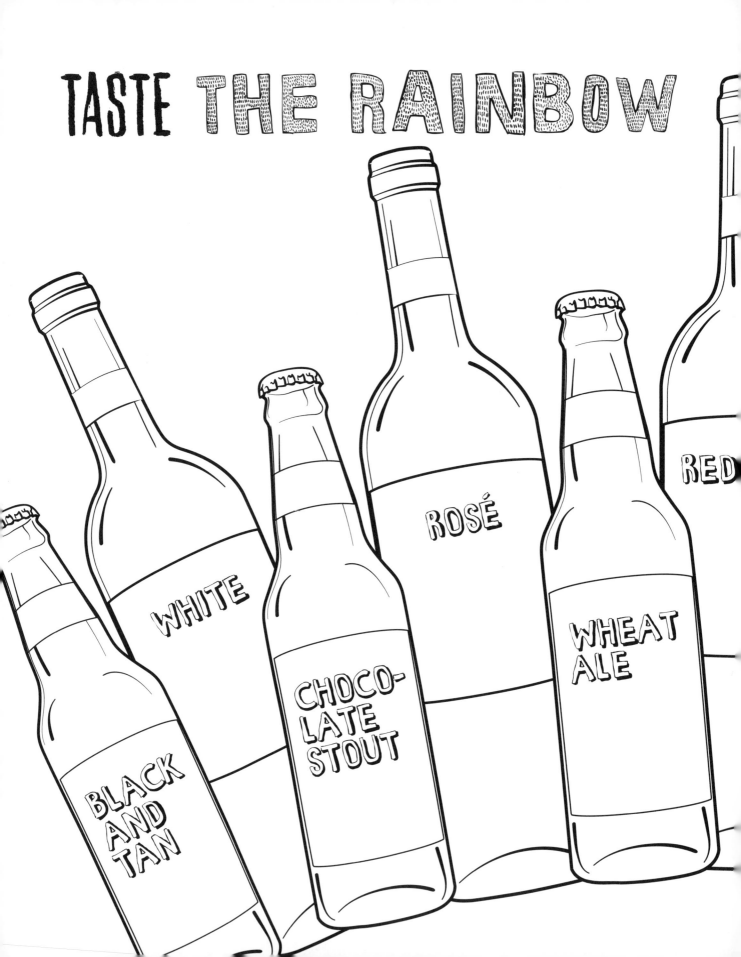

Find the crayon that best matches this spectrum of beverages and color in the bottles.

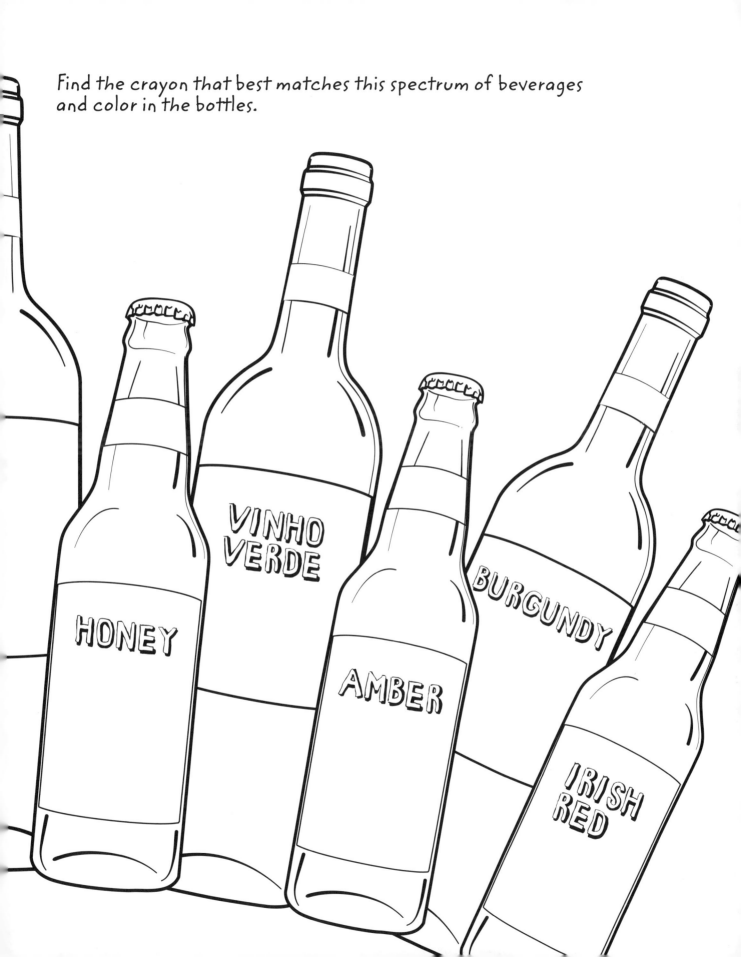

DOODLING WHILE INTOXI-CATED

WHEN CREATIVITY IS ON TAP

DRAW SOMETHING **DROWNING** IN THIS GIANT SHOT GLASS.

What kind of shot is this?

DRAW SOMEONE TAKING A **BATH** IN RED WINE.

What woes would you like to drown right now?

DRAW TINY CREATURES **CHILLING** ON THESE ICE CUBES.

SKETCH SOMEONE **SOBERING** UP IN THIS COFFEE CUP.

SNOCKERDOODLES

Use these wine stains as a starting point for your own drawing.

GRAPES WITH 'TUDE

WHITE

CHARDONNAY

- Best drunk young (does not age gracefully)
- Creamy, lush, and full-bodied
- **FLAVORS:** vanilla, butter, toast, custard, green apple, wet wool

RIESLING

- From sunny but cool locations
- High acidity, light body
- **FLAVORS:** peach, apricots, melons, minerals

SAUVIGNON BLANC

- A demanding grape, prone to over-producing
- Taut, lithe, and herbal (the opposite of chardonnay)
- **FLAVORS:** straw, hay, grass, green tea, cat pee

RED

Draw features on each type of wine grape, based on its description.

CABERNET SAUVICNON

- Angular and introverted when young, becomes rich and complex with age
- Poor cabernet usually tastes vegetal and dank
- **FLAVORS:** blackberry, black currant, cassis, mint, cedar, leather

PINOT NOIR

- Sensual, supple, silky texture and earthy aroma
- Lighter in body and color than most red wines
- **FLAVORS:** plums, baked cherries, chocolate, sweat, and damp earth

SYRAH

- Rustic, manly, and elegant
- Like a secret agent, goes by two names: Syrah in France, and Shiraz in Australia
- **FLAVORS:** wild blackberries, smoke, roasted meats, pepper, and spice

BREW ZOO

FILL THIS PAGE
with the animals that populate beer labels.

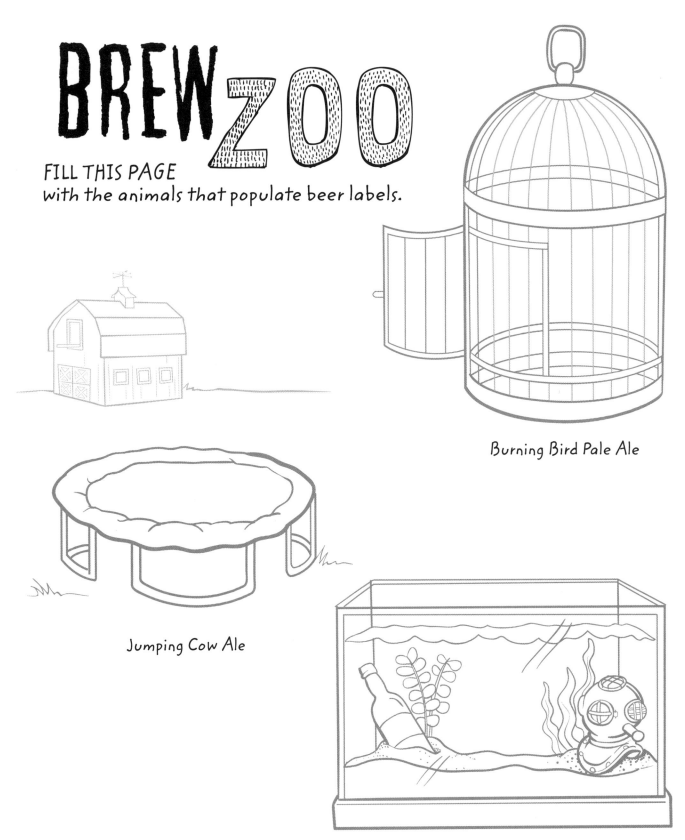

Burning Bird Pale Ale

Jumping Cow Ale

Dogfish Head Ale

Snake Dog Ale

Fat Weasel Ale

Raging Bull Ale

Draw spots, stripes, ears, and whiskers on these **PARTY ANIMALS.**

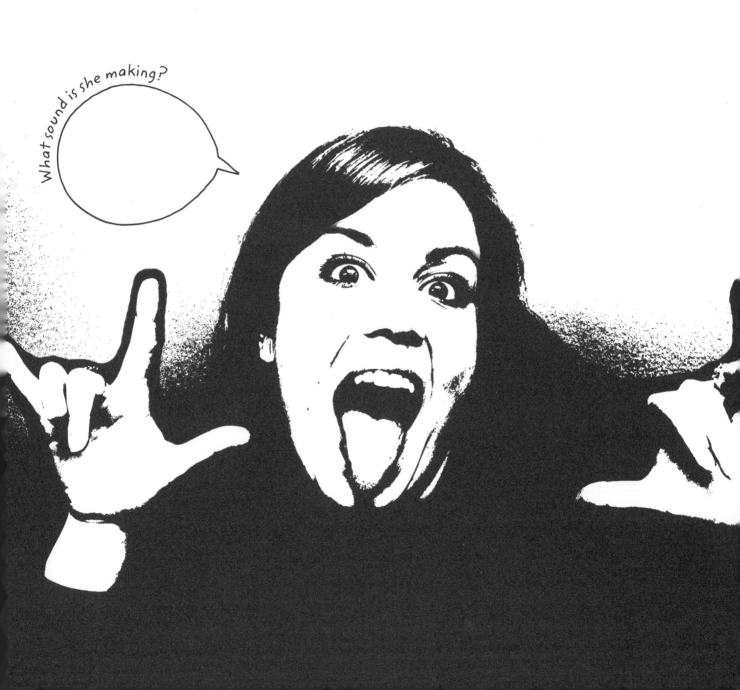

What sound is she making?

What animals would you actually like to party with? Draw them here.

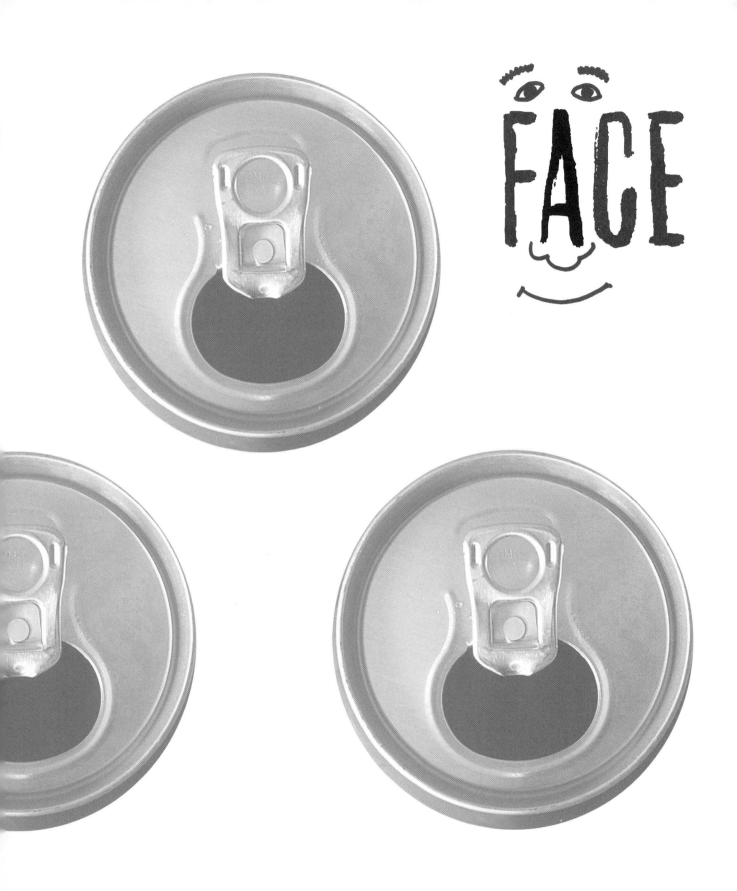

FACE

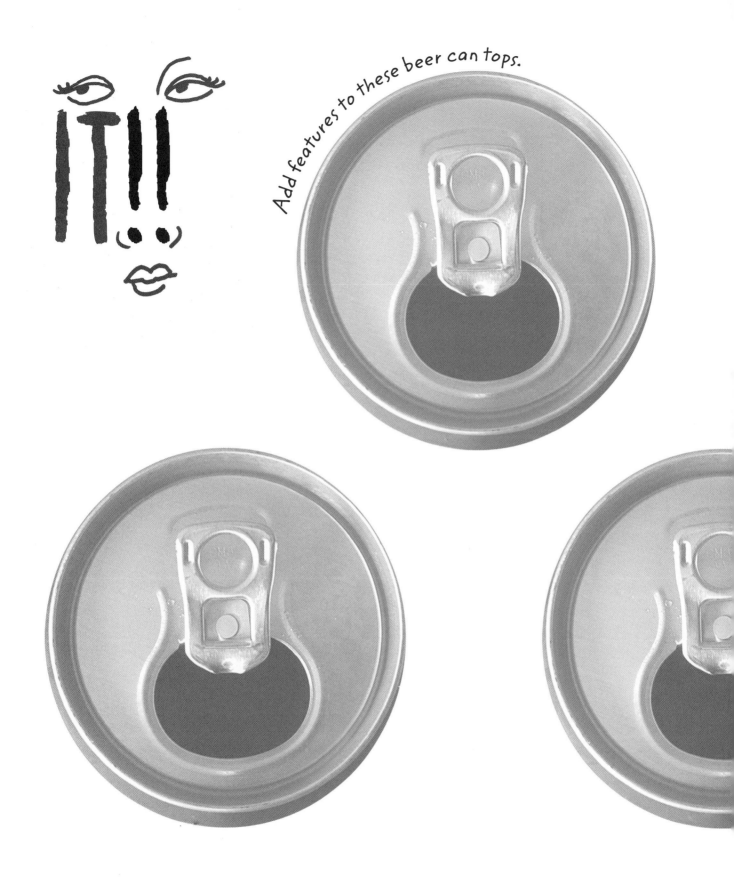

Add features to these beer can tops.

BREWSKI MEETS APPLETINI

Imagine that these two drinks are on a date. Enhance their personalities with doodles.

DUUUUDE— WTF!

IMAGINE THAT THIS MEN'S ROOM HAS BEEN:
(a) invaded by aliens
(b) overgrown with roses
(c) steampunked
(d) your choice

ARE YOU READY for ART SCHOOL?

If you like to DRAW, PAINT, or get PLASTERED, take our TALENT TEST. It's free!

PLEASE TELL US ABOUT YOUR INTEREST IN ART.

This information will be helpful in judging your drawing. Please answer each question with care.

WHAT WERE YOU DRINKING WHILE YOU DID THIS DRAWING?

HOW MUCH TIME COULD YOU DEVOTE TO ART STUDY EACH WEEK?

EVENINGS? _____ **DAYTIME?** _____ **WEEKENDS?** _____

HOW MUCH TIME COULD YOU DEVOTE TO DRINKING?

EVENINGS? _____ **DAYTIME?** _____ **WEEKENDS?** _____

TELL US HOW YOU'D LIKE TO IMPROVE: _____

Be an ARTIST
MAKE $50 TO $100 A WEEK!

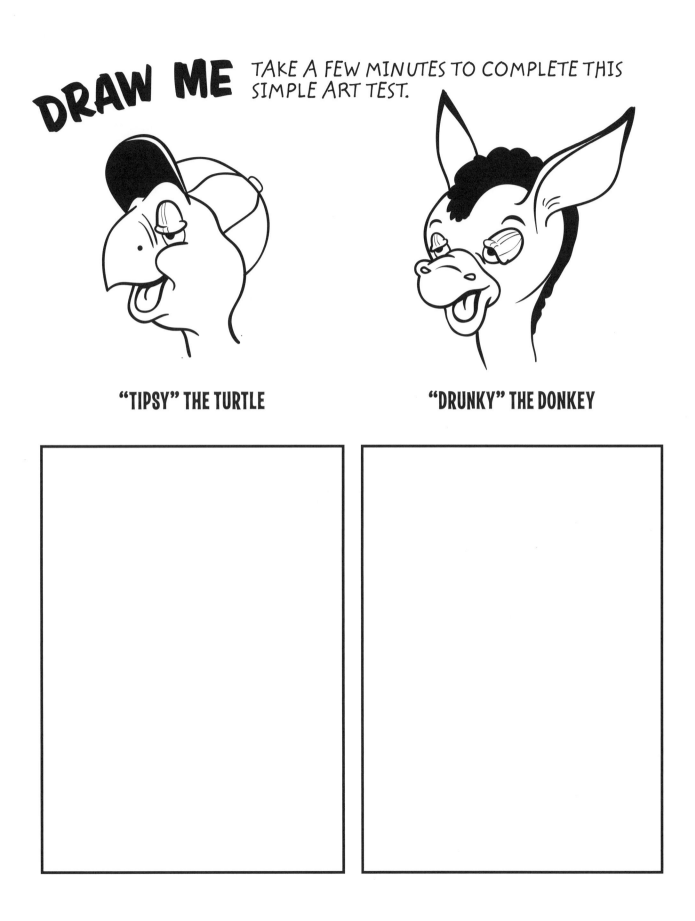

DRAW ME

TAKE A FEW MINUTES TO COMPLETE THIS SIMPLE ART TEST.

"TIPSY" THE TURTLE

"DRUNKY" THE DONKEY

MORE LESSONS WITH DRUNKY

Master the many faces of drunk by copying the example provided.

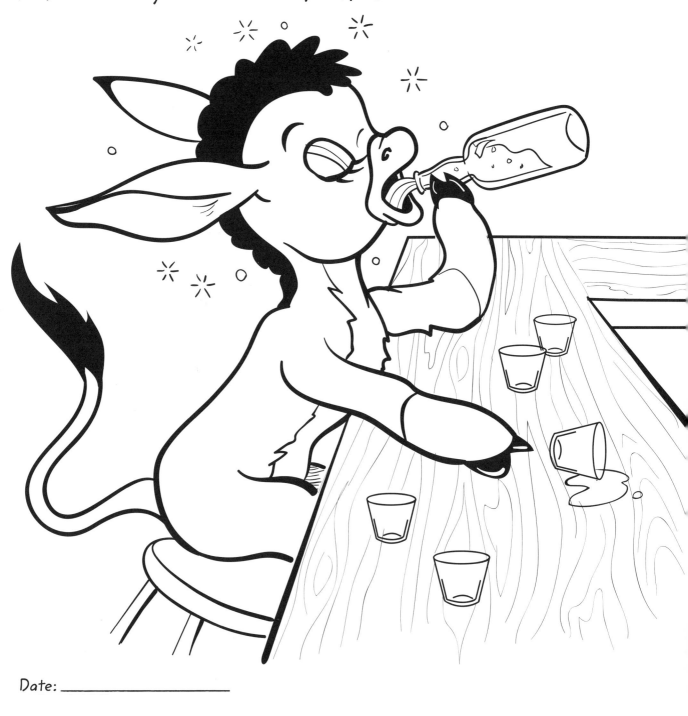

Date: _____

What I was drinking: _____

TIPSY

HAPPY

BLOTTO

SLOPPY

MEAN

HUNGOVER

PORTRAIT OF THE ARTIST SOBER

PORTRAIT OF THE ARTIST DRUNK

PORTRAIT OF A PASSED-OUT FRIEND

Use the faces of these unconscious people as your canvas.

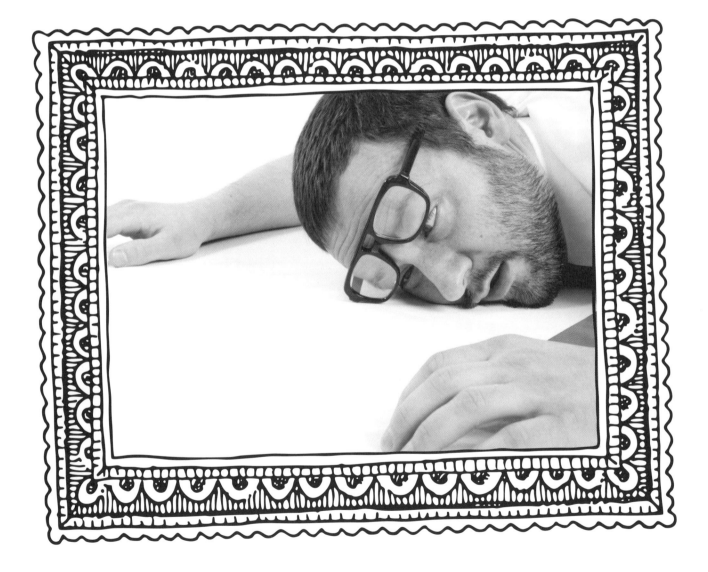

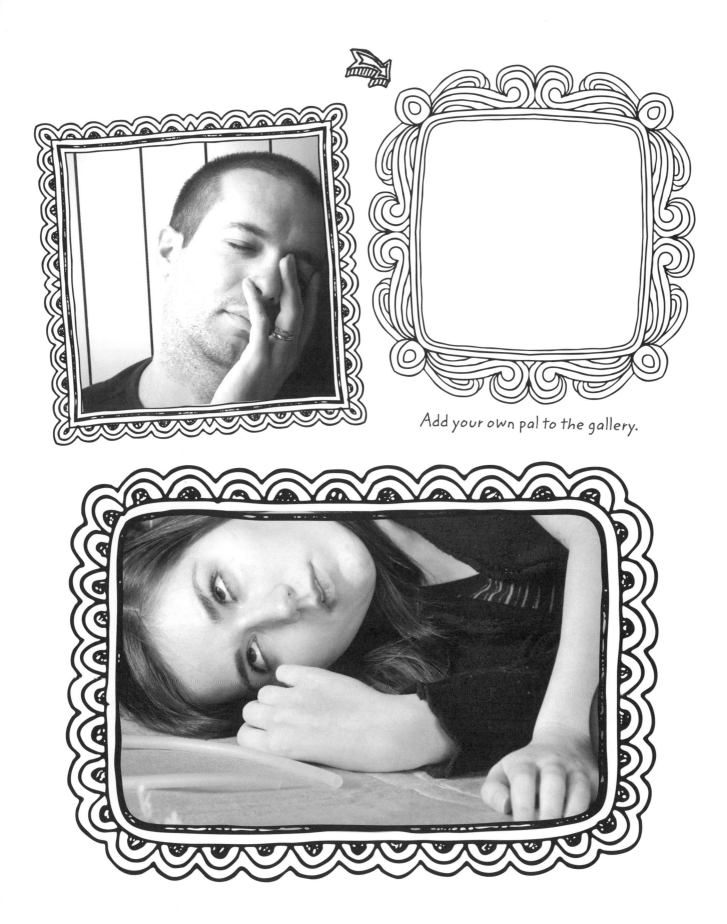

Add your own pal to the gallery.

BIG NOSE, FULL BODY

Get smashed with a friend and ask him or her to sit for a Picasso-inspired portrait.

Color in this painting for practice.

Portrait of_____ after _____ drinks.

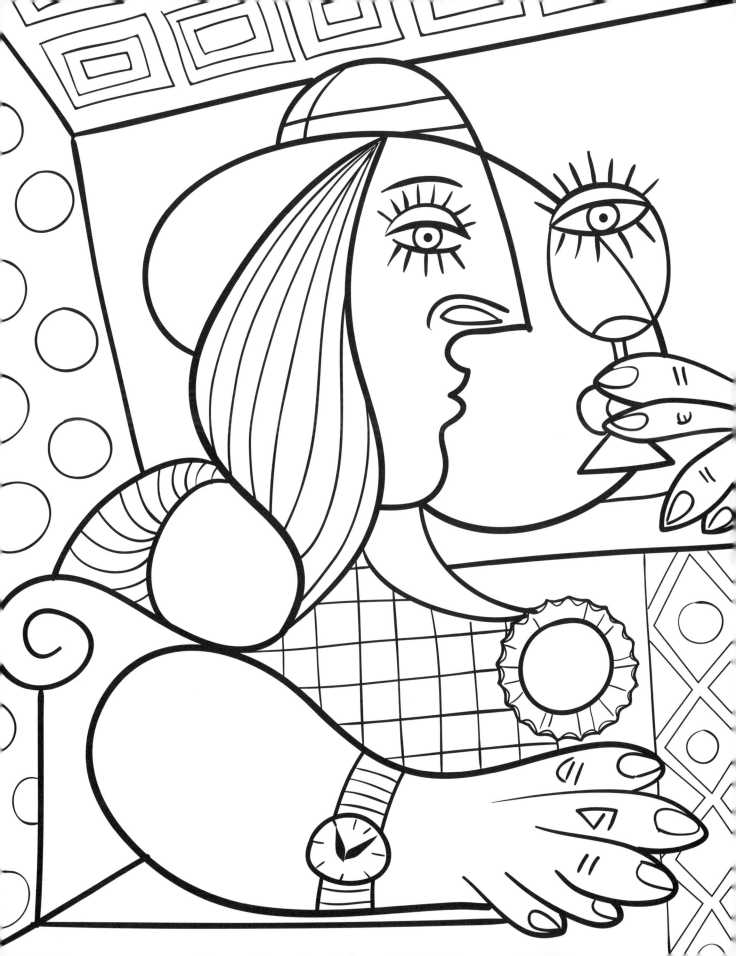

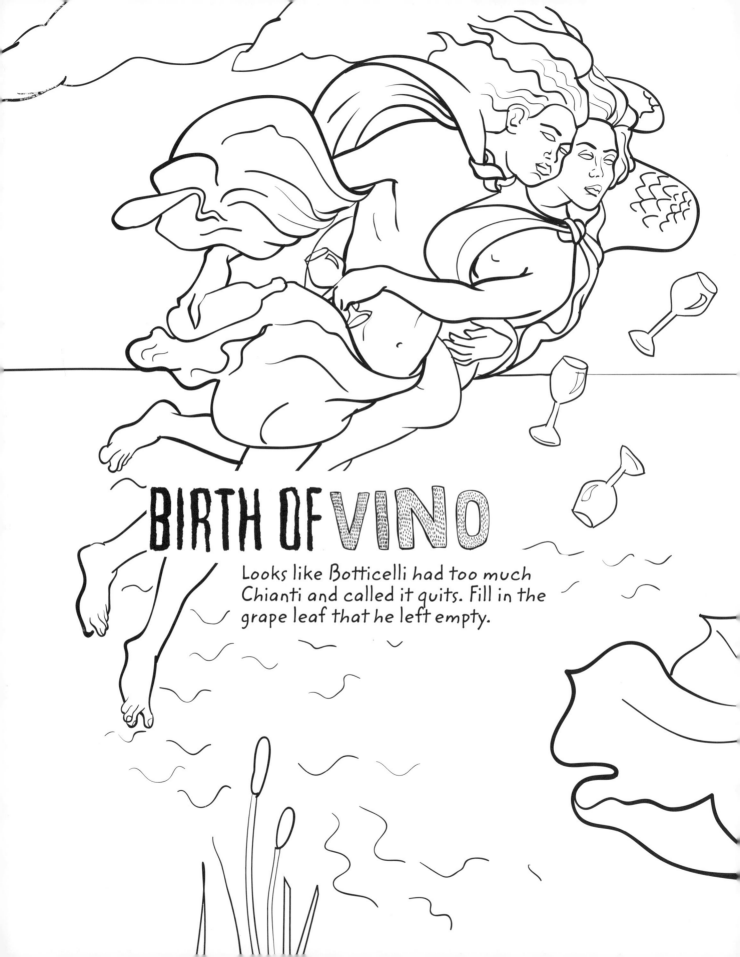

BIRTH OF VINO

Looks like Botticelli had too much Chianti and called it quits. Fill in the grape leaf that he left empty.

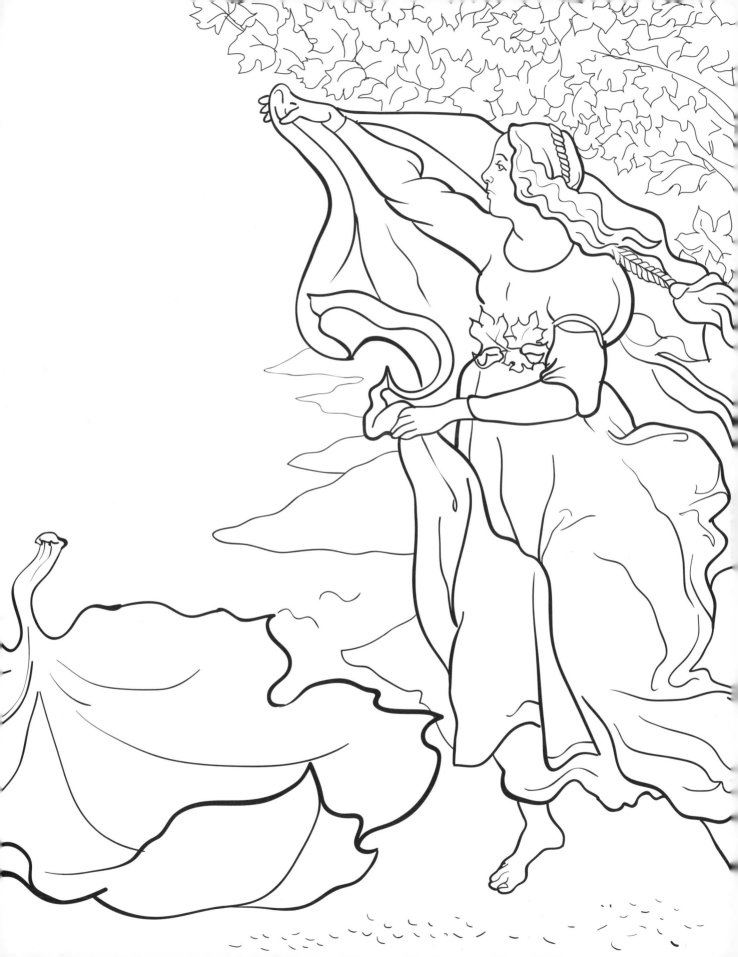

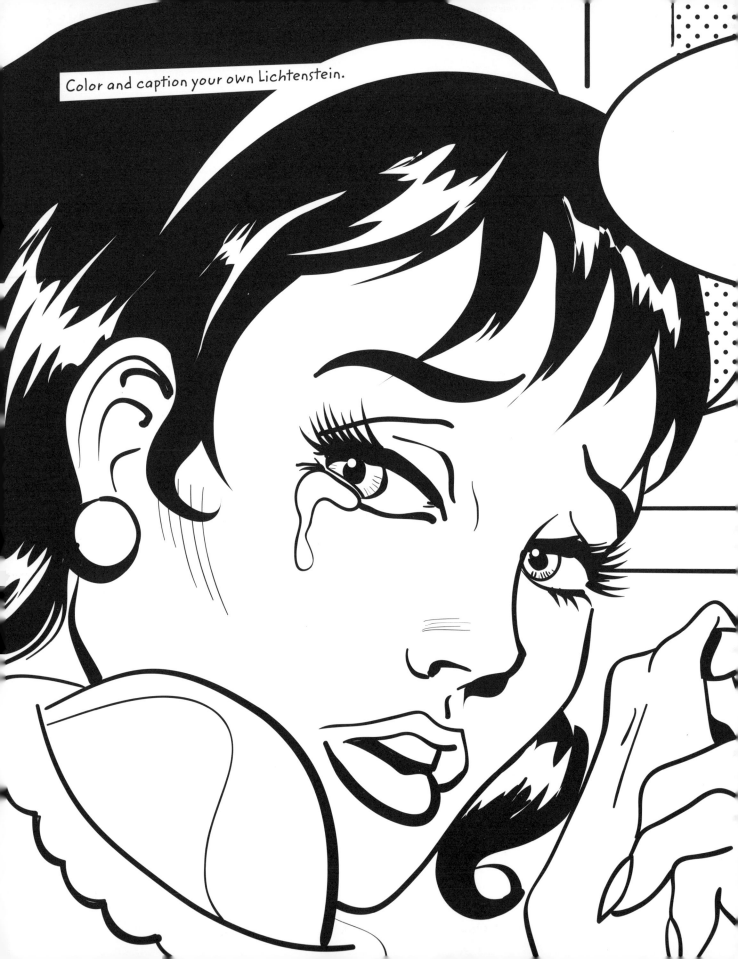

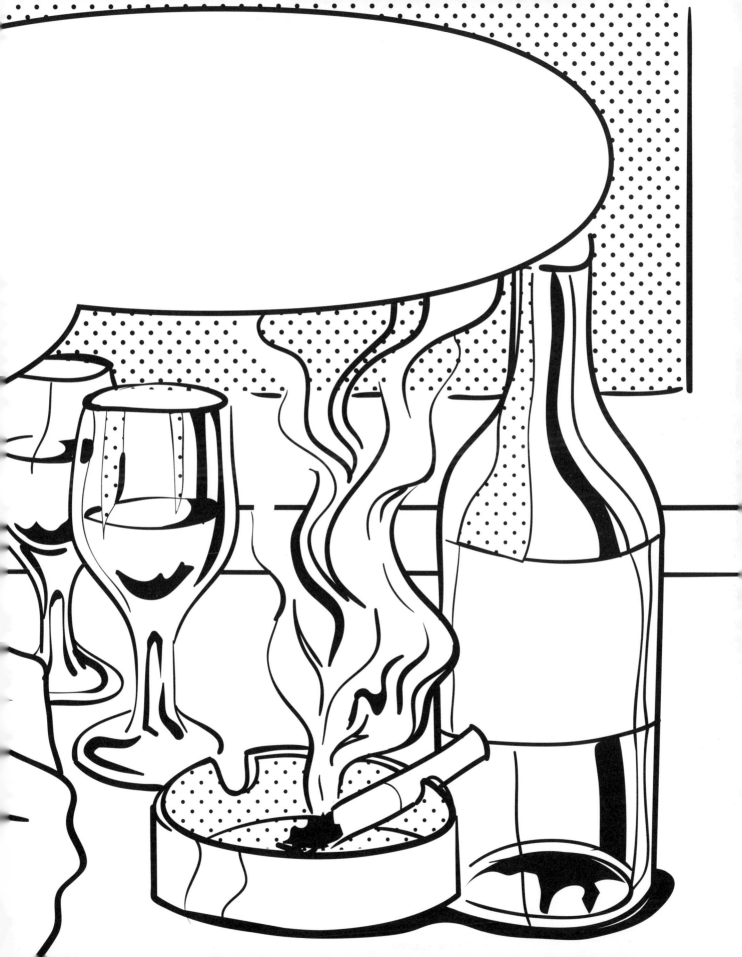

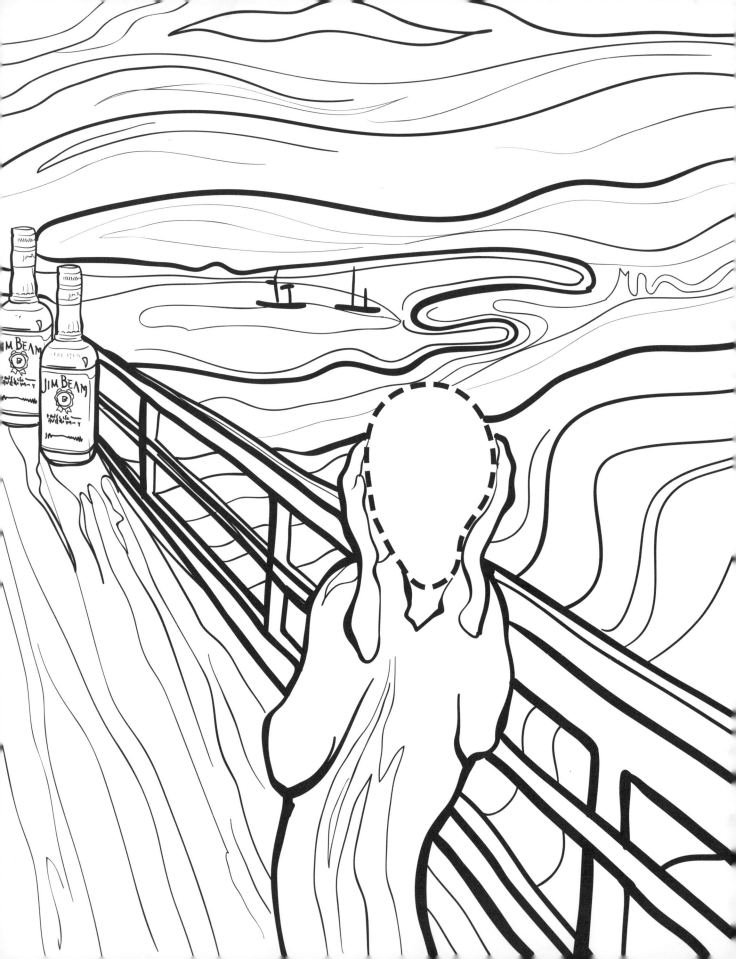

CREEK TRAGEDY

Art historians think these sculptures fell and broke their limbs after a bacchanalian bash. Doodle something new over the missing pieces.

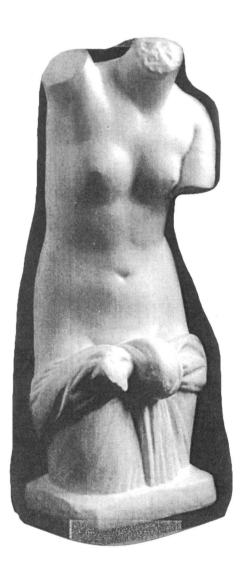

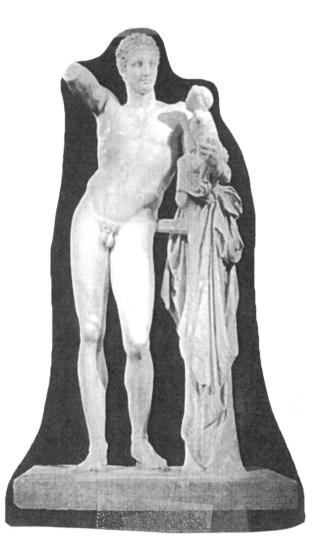

These guys really can't hold their liquor. Invent a way to help these armless fools enjoy their cocktails.

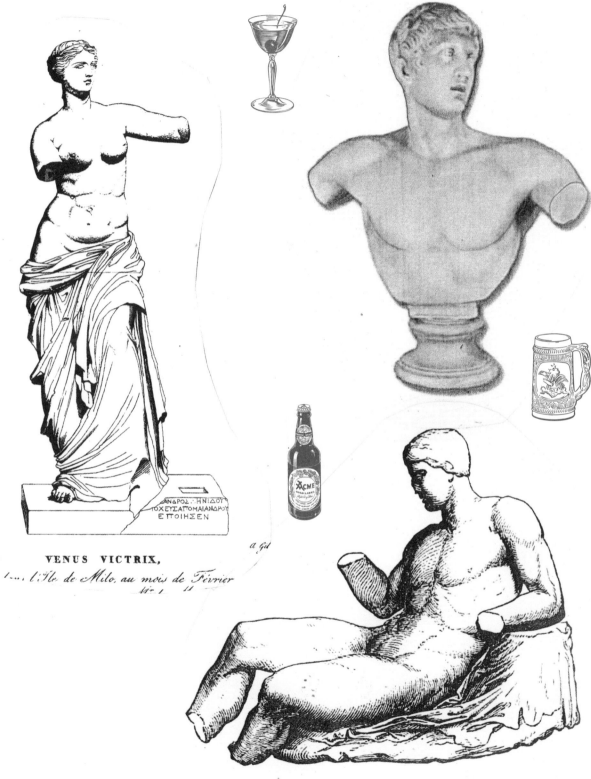

VENUS VICTRIX,

de l'Ile de Milo, au mois de Février

CREATIVE CAREERS

DRINKING ON THE JOB

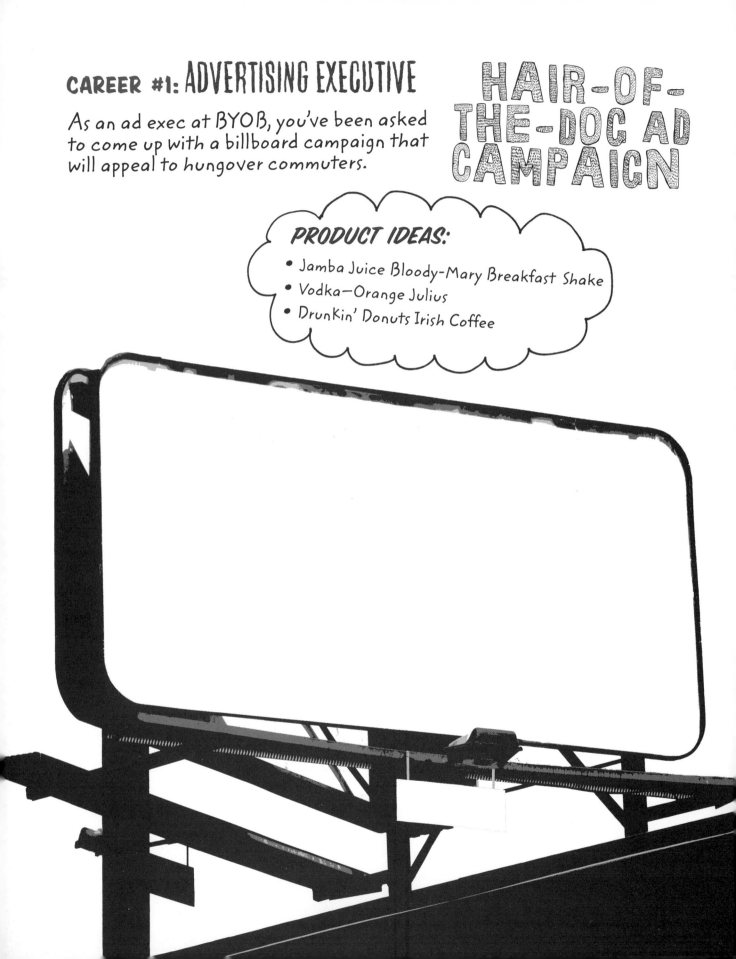

CAREER #1: ADVERTISING EXECUTIVE

As an ad exec at BYOB, you've been asked to come up with a billboard campaign that will appeal to hungover commuters.

HAIR-OF-THE-DOG AD CAMPAIGN

PRODUCT IDEAS:
- Jamba Juice Bloody-Mary Breakfast Shake
- Vodka—Orange Julius
- Drunkin' Donuts Irish Coffee

CAREER #2: BREWMASTER

You're in charge of naming a beer and designing the label. It's not as hard as it sounds.

GENIUS IS BREW-ING

FOR A GERMAN-SOUNDING BEER:

A street or city + "bock" or "weizen"
EXAMPLES—New Havenbock or Portlandweizen

FOR A SMALL MICROBREWERY:

Any adjective + any non-sequitur noun
EXAMPLES—Roving Lighthouse, Jubilant Hat, Serious Dachshund

FOR STANDARD AMERICAN BEER:

The word Coors, Bud, or Miller + an adjective or fruit
EXAMPLES—Miller Rank, Coors Elderly, Bud Strawberry

DESIGN THE LABELS ON THESE BOTTLES USING ANY OF THESE IDEAS OR ONE OF YOUR OWN.

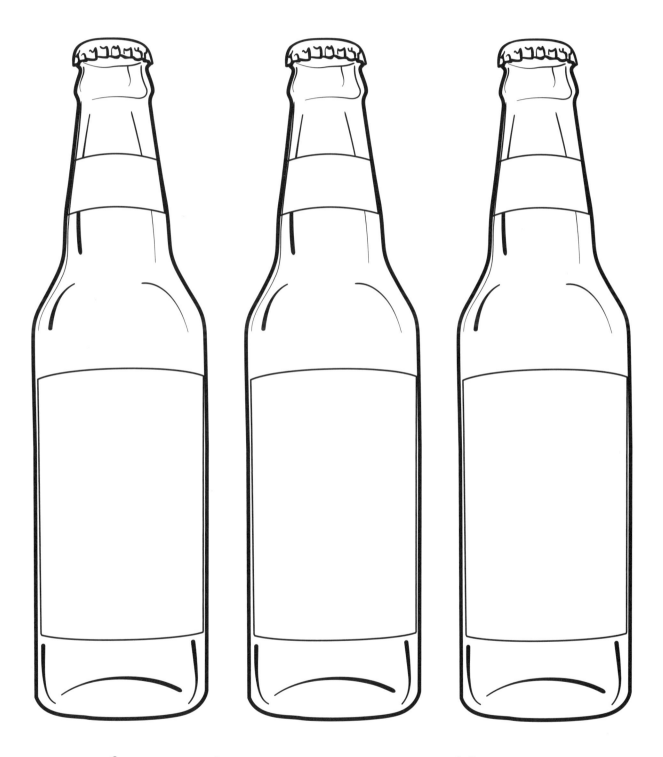

Generate more beer names using the game on the following page.

BEER NAME GENERATOR

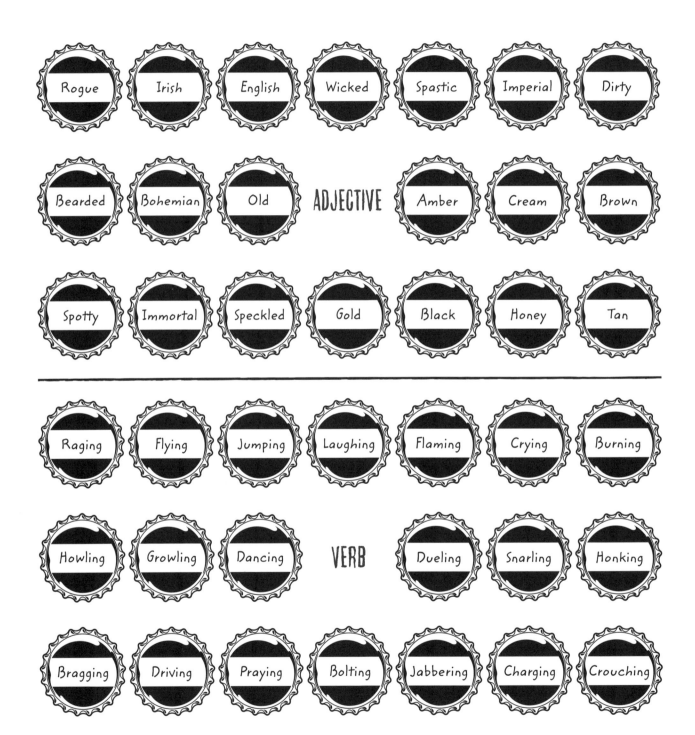

Rogue · Irish · English · Wicked · Spastic · Imperial · Dirty

Bearded · Bohemian · Old · **ADJECTIVE** · Amber · Cream · Brown

Spotty · Immortal · Speckled · Gold · Black · Honey · Tan

Raging · Flying · Jumping · Laughing · Flaming · Crying · Burning

Howling · Growling · Dancing · **VERB** · Dueling · Snarling · Honking

Bragging · Driving · Praying · Bolting · Jabbering · Charging · Crouching

Flip a bottle cap until it lands on three different words (including a beer style). Arrange the words to create artisanal-sounding brews.

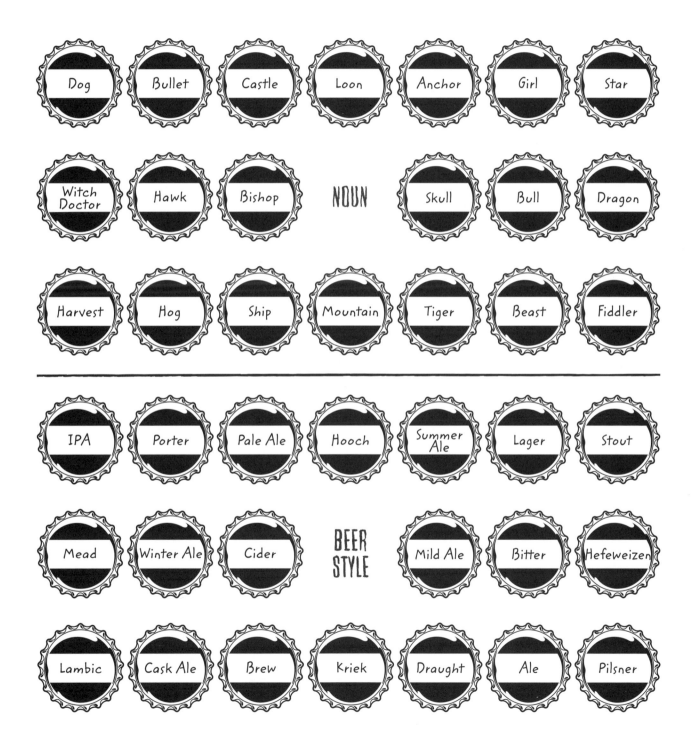

Dog · Bullet · Castle · Loon · Anchor · Girl · Star

Witch Doctor · Hawk · Bishop · NOUN · Skull · Bull · Dragon

Harvest · Hog · Ship · Mountain · Tiger · Beast · Fiddler

IPA · Porter · Pale Ale · Hooch · Summer Ale · Lager · Stout

Mead · Winter Ale · Cider · BEER STYLE · Mild Ale · Bitter · Hefeweizen

Lambic · Cask Ale · Brew · Kriek · Draught · Ale · Pilsner

DESIGN A DRINK-ING SHIRT

IS FOR LOVERS

Original

HOW MANY DRINKS WOULD IT TAKE TO ENJOY HANGING WITH THESE GUYS?

——— 0 shots

0 glass(es) of _____

PRACTICE MAKING
REGRETTABLE TATTOOS

IDEAS for BAD TATTOOS

#1 The logo of the fast food you just ate

#2 A butterfly with your girlfriend's face between the wings

#3 A yin-yang sun (or anything involving a yin-yang)

DRAW A SLEEVE ON THIS POOR SOUL.

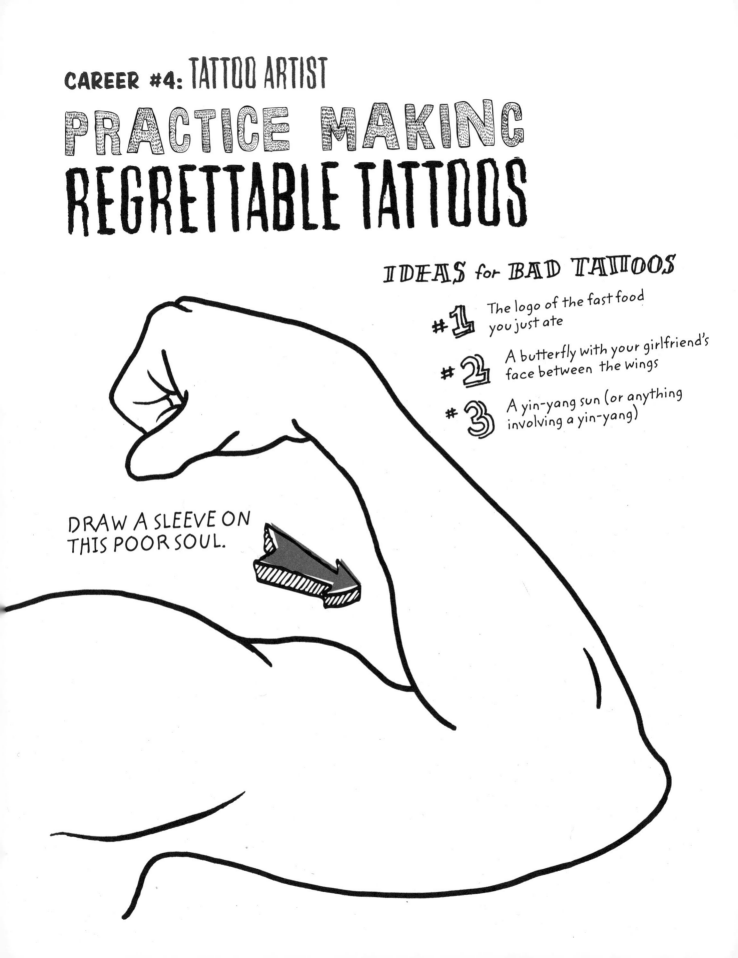

"Thug Life" HAS BEEN DONE.

COME UP WITH NEW SLOGANS FOR THESE KNUCKLES.

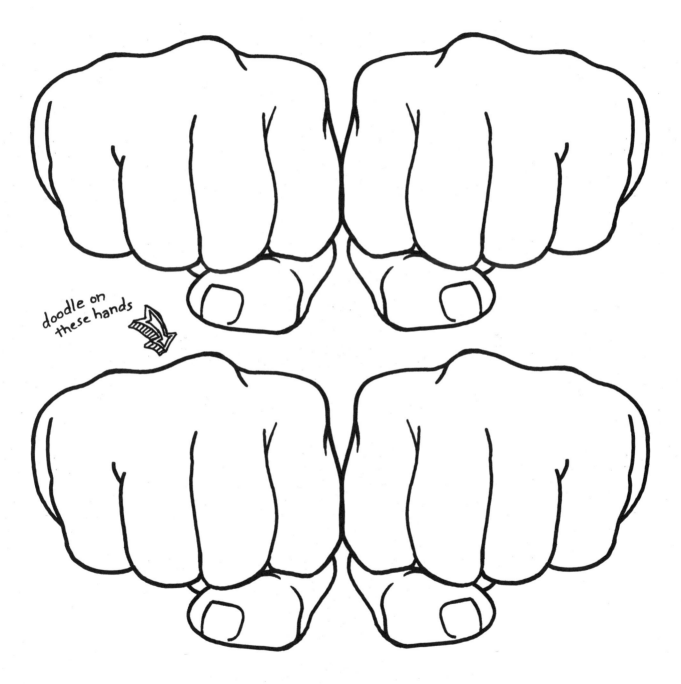

doodle on these hands

After _____ drinks, this started to look kind of cool.

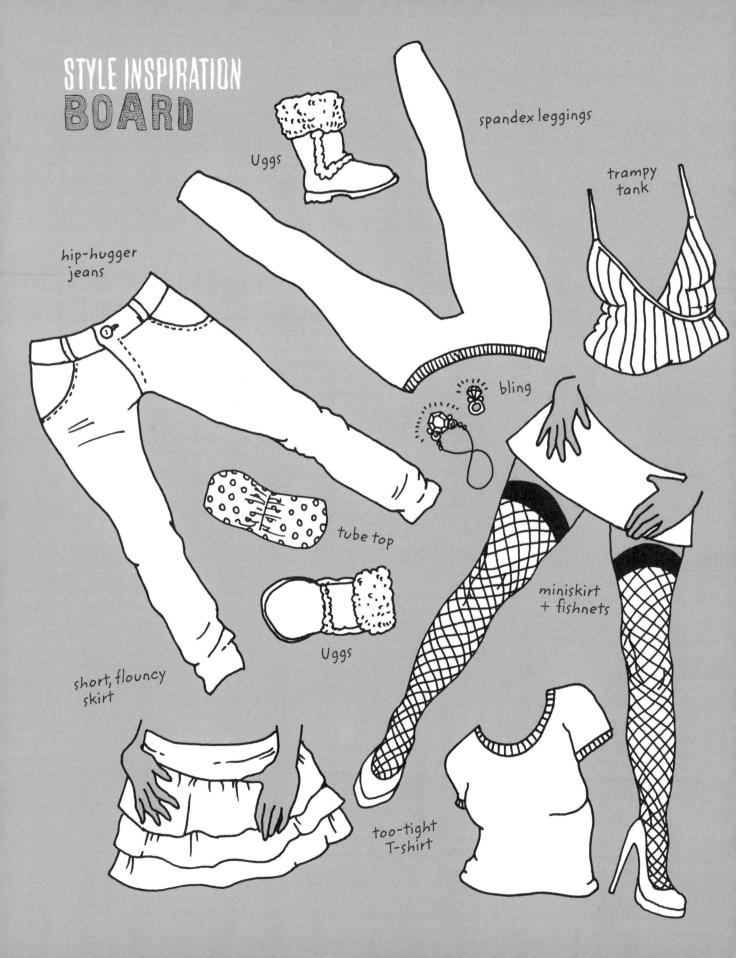

STYLE INSPIRATION
BOARD

Uggs

spandex leggings

trampy tank

hip-hugger jeans

bling

tube top

Uggs

miniskirt + fishnets

short, flouncy skirt

too-tight T-shirt

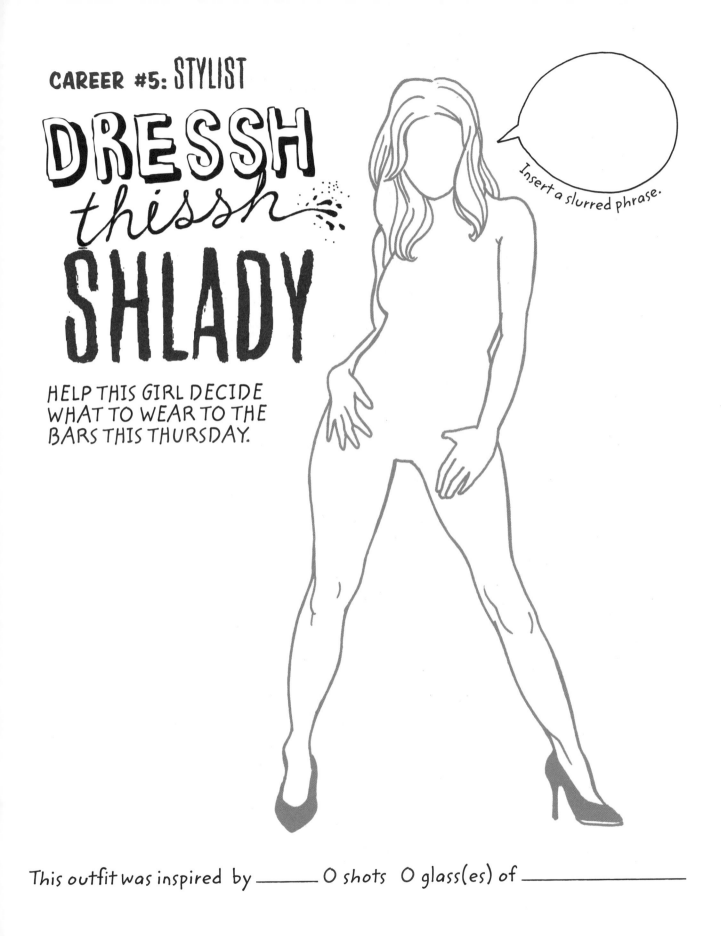

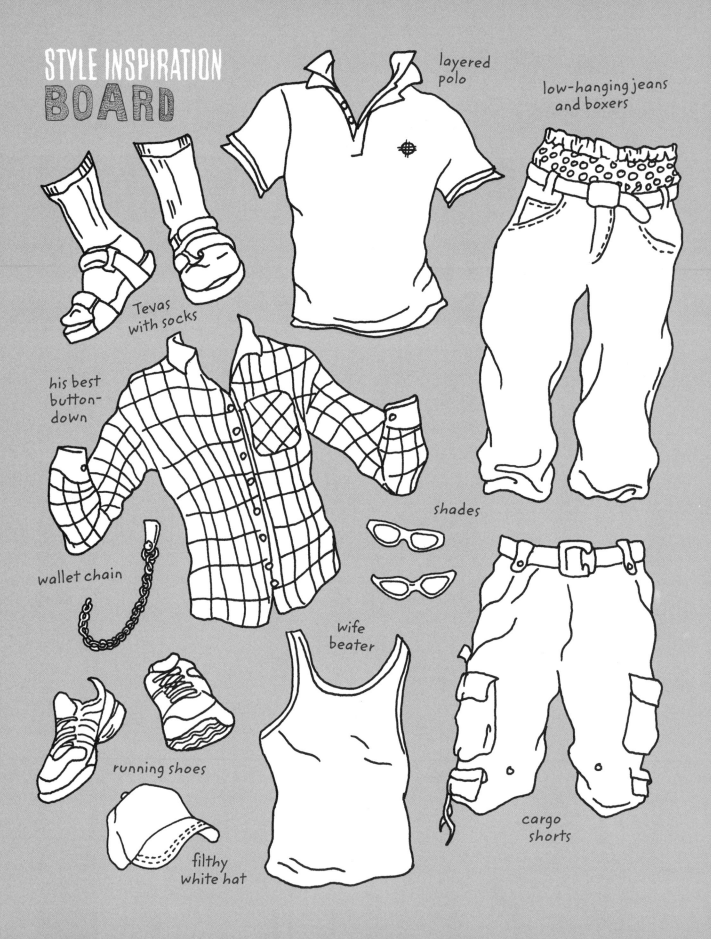

STYLE INSPIRATION
BOARD

layered
polo

low-hanging jeans
and boxers

Tevas
with socks

his best
button-
down

shades

wallet chain

wife
beater

running shoes

filthy
white hat

cargo
shorts

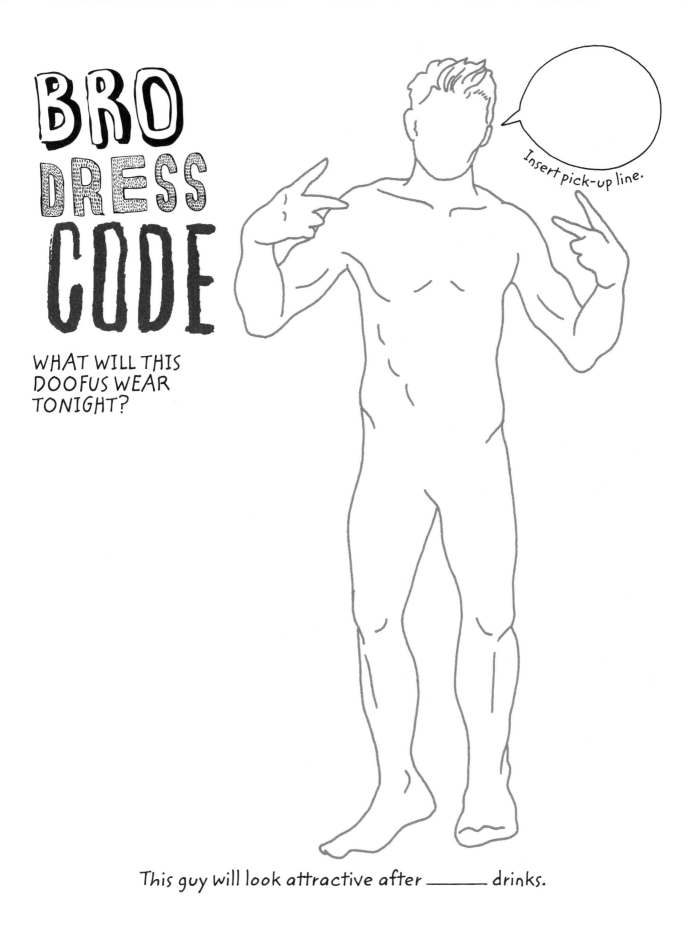

TRANS- FORM THIS SPACE

The furniture has been conveniently removed from the living room of this McMansion, providing ample room for keg stands. Redecorate accordingly.

CAREER #7: SHORT-ORDER COOK/FOOD STYLIST

JOT DOWN A RECIPE FOR THE PERFECT POST-BINGE MEAL.

YOUR CURE FOR THE "DRUNCHIES"

From the kitchen of...

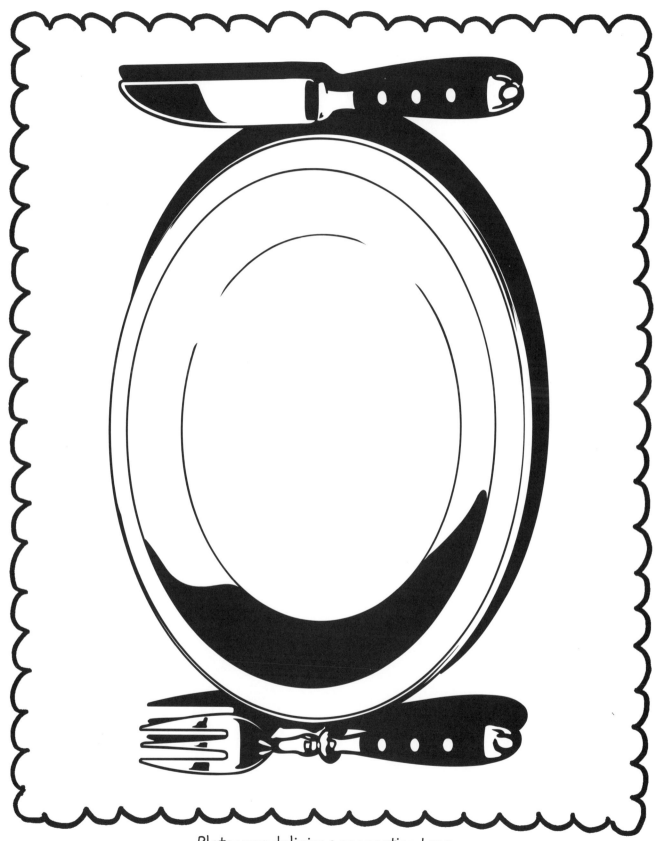

Plate your delicious concoction here.

CAREER #8: PRODUCT DESIGNER

BOOZE ON THE MOVE

COLOR IN THESE FLASKS.

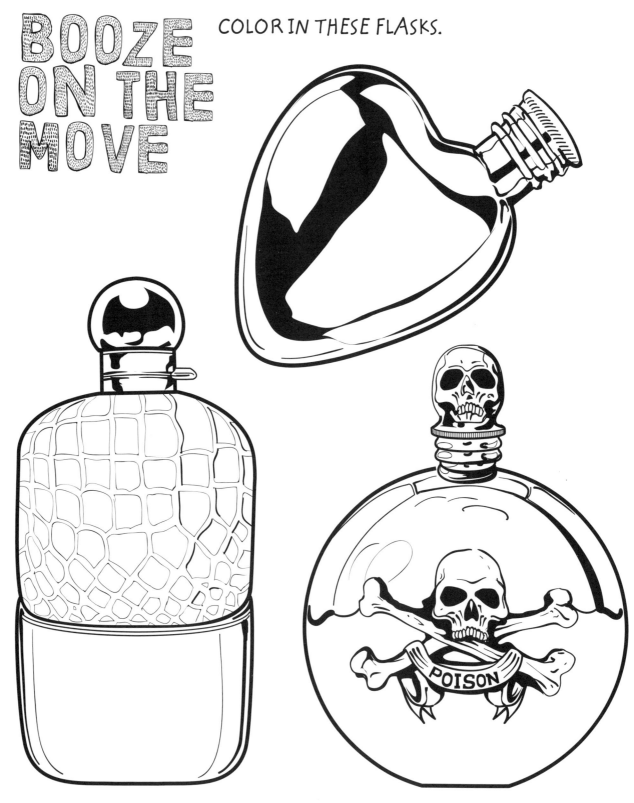

Design customized portable flasks for these busy people.

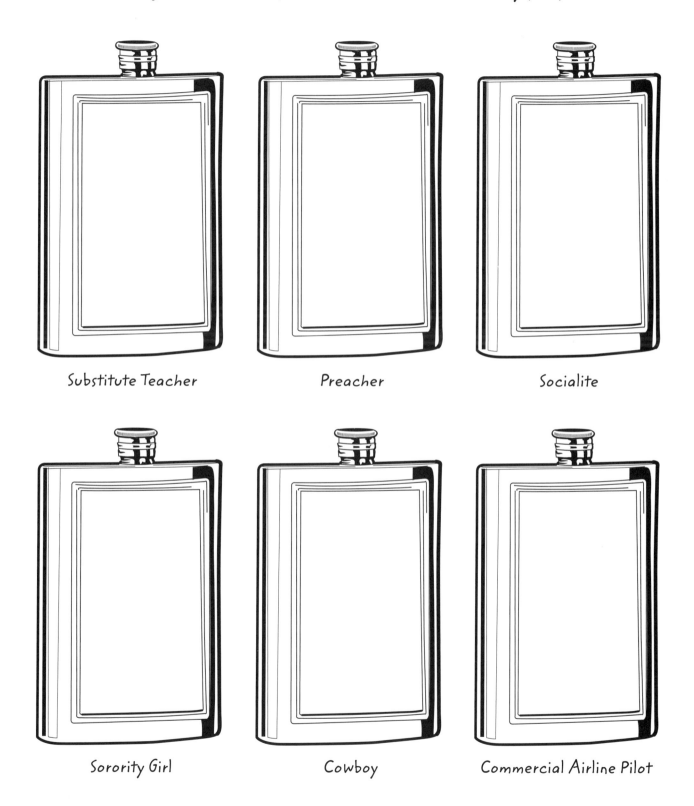

Substitute Teacher

Preacher

Socialite

Sorority Girl

Cowboy

Commercial Airline Pilot

HAPPY HOUR

GAMES TO PASS THE TIME

LET'S GET THIS OFFICE PARTY STARTED

SAMPLE:

NAME: Dave **AGE:** 29

OCCUPATION: Sales, but spends most of the day checking fantasy football

HR WARNING: Using empty liquor bottles as cubicle decorations is against office policy

HR PRAISE: Thanks for setting up the Super Bowl pool

STYLE: Thinks wide ties make his shoulders look bigger

DRINKING ACTIVITY: Fighting with 10-year-olds over Xbox LIVE

NAME: _____ AGE: _____

OCCUPATION: _____

HR WARNING: _____

HR PRAISE: _____

STYLE: _____

DRINKING ACTIVITY: _____

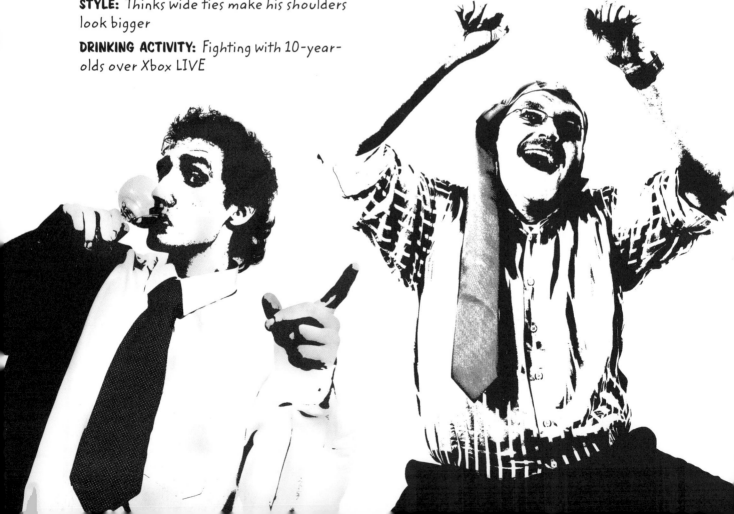

Create Human Resources profiles for these fun-loving employees.
Doodle over them to show how they look by the end of the celebration.

NAME: _____ AGE: _____
OCCUPATION: _____

HR WARNING: _____

HR PRAISE: _____

STYLE: _____

DRINKING ACTIVITY: _____

NAME: _____ AGE: _____
OCCUPATION: _____

HR WARNING: _____

HR PRAISE: _____

STYLE: _____

DRINKING ACTIVITY: _____

1 TO 15	16 TO 30	31 TO 45	46 TO 60	61 TO 75
GUY LOOKING FOR FIGHT	ACCIDENTAL UNDERWEAR FLASH	SOMEONE BUYS YOU A DRINK	A SUGAR DADDY	A LONE DRINKER
BACHELOR PARTY	21ST BIRTHDAY PARTY	PEOPLE MAKING OUT	A COUGAR	DRUNK DANCING
FOREIGNER PLAYING ON JUKEBOX	FAKE ID REJECTED	★	SOMEONE FALLS	DRUNK SINGING
SOMEONE DANCING ALONE	A HIPSTER DRINKING PABST	SOMEONE CRYING	SOMEONE DOING BAR TRICKS	A SPILLED DRINK
NEON SIGN	SOMEONE FLIRTING WITH BARTENDER	SOMETHING BREAKS	BACHELOR-ETTE PARTY	SOMEONE HITS ON YOU

Put the "win" in wine by challenging a friend to a game of bar-related bingo. The first person to spot five of these in a row wins a free round. This is best played at a dive bar.

BINGO

1 TO 15	16 TO 30	31 TO 45	46 TO 60	61 TO 75
PEOPLE MAKING OUT	BACHELOR PARTY	FOREIGNER PLAYING ON JUKEBOX	SOMEONE DANCING ALONE	NEON SIGN
21ST BIRTHDAY PARTY	ACCIDENTAL UNDERWEAR FLASH	FAKE ID REJECTED	A HIPSTER DRINKING PABST	SOMEONE FLIRTING WITH BARTENDER
SOMEONE BUYS YOU A DRINK	SOMEONE HITS ON YOU	★	SOMEONE CRYING	SOMETHING BREAKS
A SUGAR DADDY	A COUGAR	SOMEONE FALLS	SOMEONE DOING BAR TRICKS	BACHELOR-ETTE PARTY
A LONE DRINKER	DRUNK DANCING	A SPILLED DRINK	DRUNK SINGING	GUY LOOKING FOR FIGHT

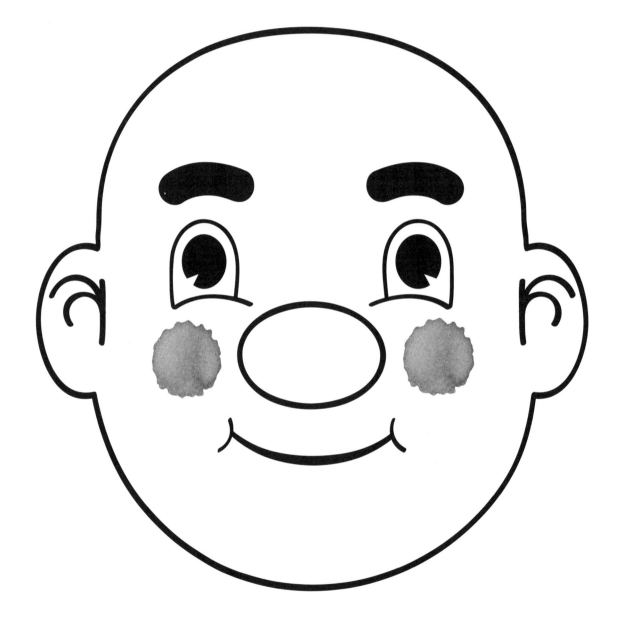

Use peanuts, pretzels, bottle caps, and other odds-and-ends at the bar to decorate Mr. and Mrs. Plain-Head.

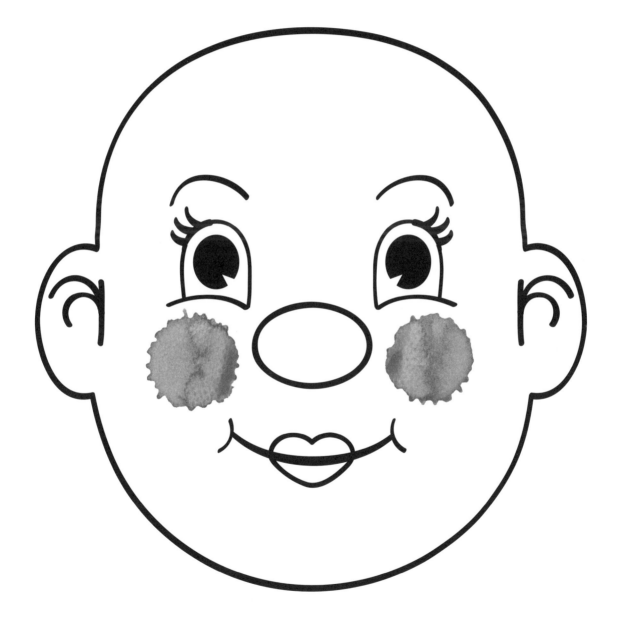

DECODE THESE DRUNK TEXTS

GUESS WHAT EACH OF THESE INTEXTICATED PEOPLE INTENDED TO SAY:

(A) CAN YUK CP ME PICK ME UL?

(B) HEY CURTIS HERS MINI BET

(C) CO R HOLD MY HAIR Β K

(D) THEINR FOR THE BATHROOM JS RIDIMURDS. FOUGHT OUTSIDE.

(E) I CAN DDR YOU R PANDER

(F) CAN'T FOND YOU WEREWACING

(G) OILED IN THE HALLWAY

(H) I THINK IM FINE TO FRICE

(I) HELOOOOOOOOOOOOOOOOOOOOOOOOOOO

(J) I'M DRIKN

(K) DO YOU GIVE A SPARE SHEET

(L) GOIN MCDONAJDA

(M) DO YOU HAVE A SULFUR CONDOM

(N) THIS PARTY'S PUT IS BOOZE. WANNA BOUNCE

(O) WHERE ARE YOU I NEED A WINDBAG

(P) RELAX NATIVE WILL NO THE WINDOW IS DONE

(Q) I THINK HES PAWED PUT IN THE BUSH

(R) THE BARTYSENGER CUT ME OFF BUR ME SUMTING

ANSWERS

ILLUSTRATED IN THE PHONE SCREEN: Where's the party at? (A) Can you come pick me up? (B) Hey cutie, here's my number. (C) Come hold my hair back. (D) The line for the bathroom is ridiculous. Going outside. (E) I can see your panties. (F) Can't find you. We're leaving. (G) I puked in the hallway. (H) I think I'm fine to drive. (I) Hello. (J) I'm drunk. (K) Do you have a spare shirt? (L) Going to McDonald's. (M) Do you have a spare condom? (N) This party's out of booze. Want to bounce? (O) Where are you? I need a wingman. (P) Relax. No one will notice the window is gone. (Q) I think he's passed out in the bush. (R) The bartender cut me off. Buy me something.

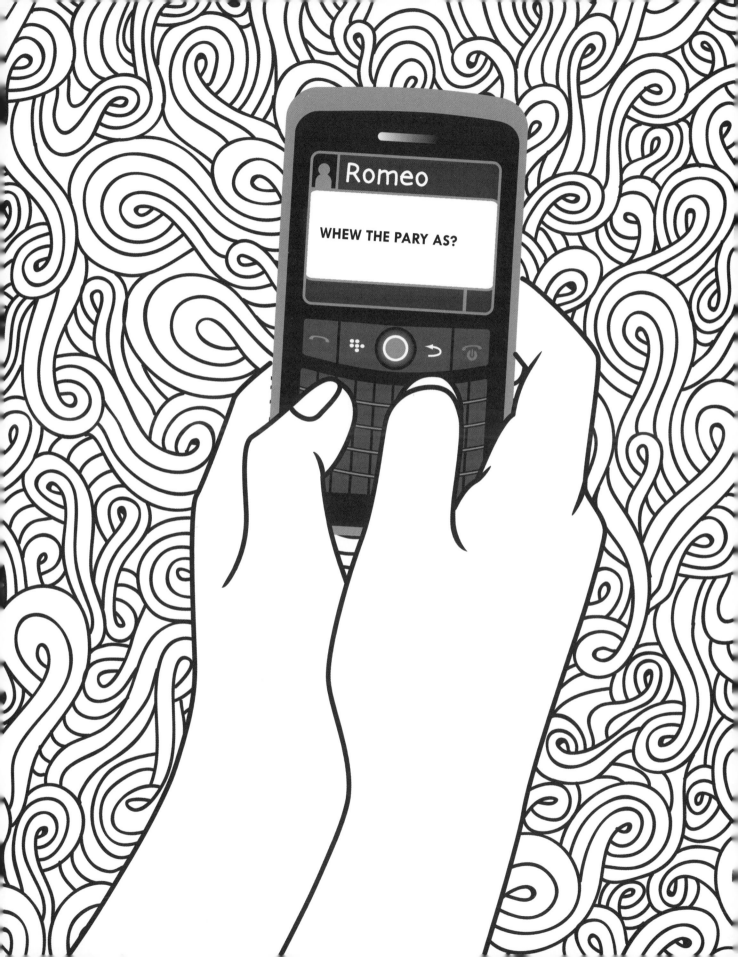

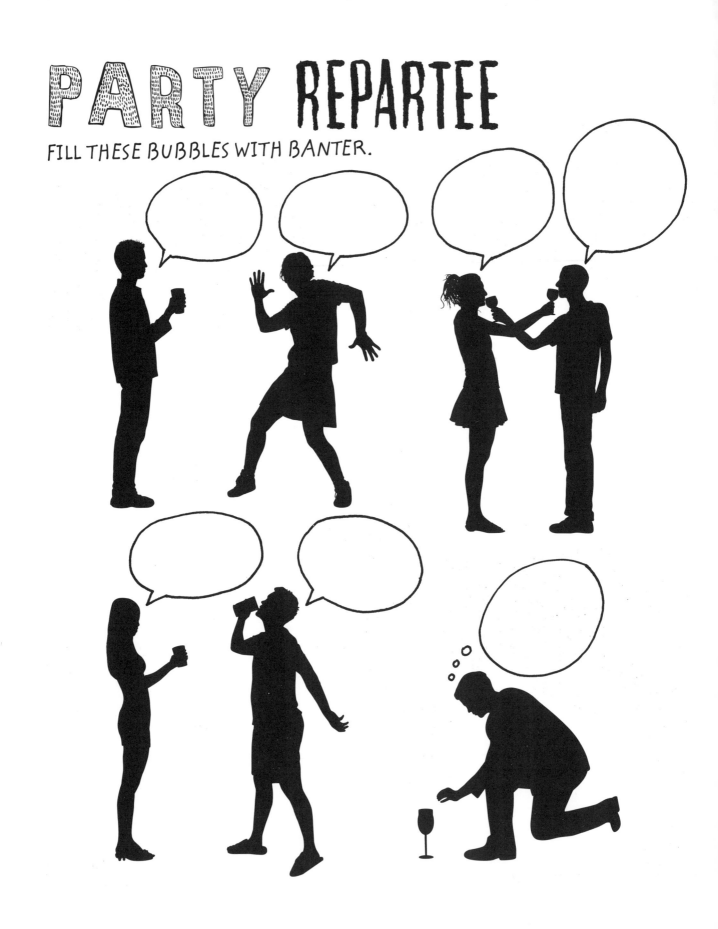

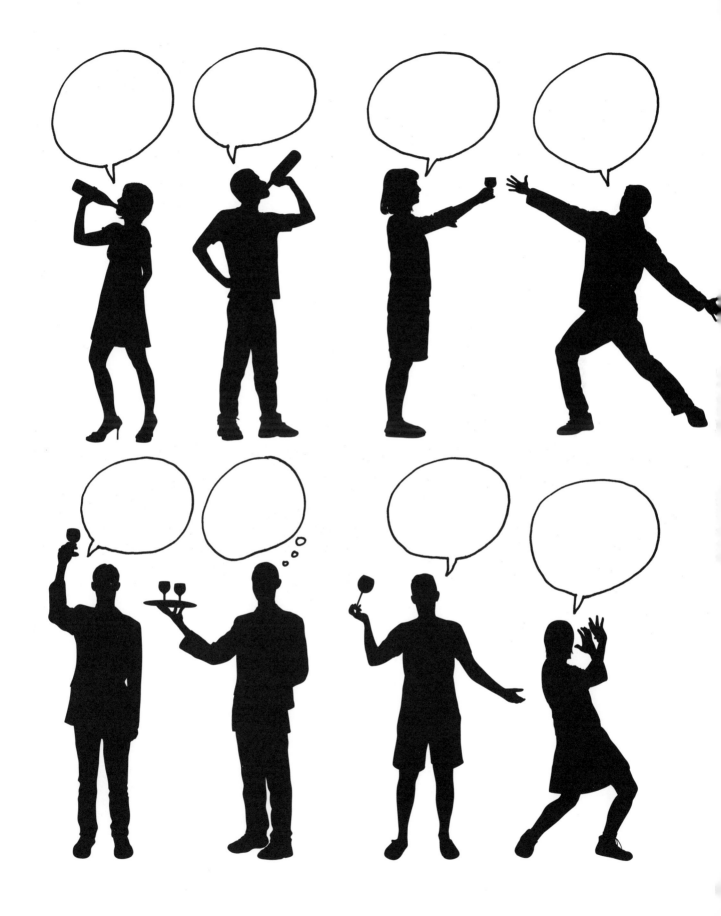

CHALLENGE for the
B-DAY CELEBRANT

HERE'S YOUR DRINKING TO-DO LIST:

☐ Whenever a song comes on that references alcohol, you must drink that alcohol.

☐ A beer for each letter in your name (Example: Schlitz, Amstel, Red Stripe, Anheuser-Busch, Heineken = Sarah).

☐ Throw back a shot for each of your exes.

☐ Whenever a song mentions your name (or is performed by someone with your name), you must take a shot.

☐ Drink a glass of scotch or wine that is at least as old as you are.

☐ Order a pitcher of beer. Keep chugging all the way through the happy birthday song.

BONUS: If you are still standing:

☐ Put a flaming shot of Bacardi 151 on your birthday cake. Blow it out and swill the rum. Eating the cake is optional.

Cut out and pin to your shirt before going on a binge.

HELLO
my name is

If LOST/PASSED OUT/MAKING OUT with a stranger, please call: _____

Order me a _____ for when I wake up.

I've probably dropped my _____ . Please help me find it.

If I mention _____ , order me another. I'm drinking to forget.

RAISING THE BAR ☆

Cut out these certificates and award them to your drinking buddies:

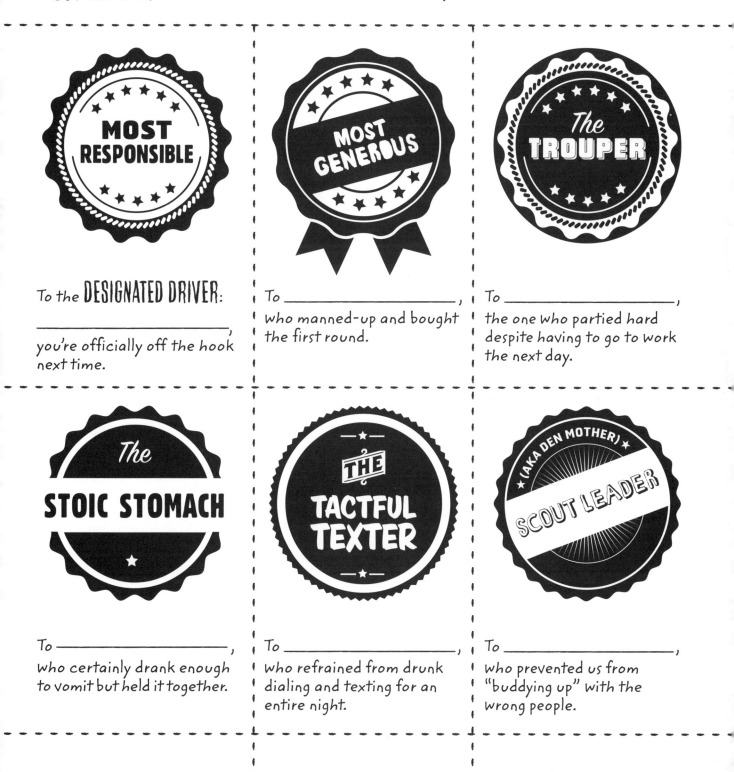

MOST RESPONSIBLE

To the **DESIGNATED DRIVER**:
_____,
you're officially off the hook next time.

MOST GENEROUS

To _____,
who manned-up and bought the first round.

The **TROUPER**

To _____,
the one who partied hard despite having to go to work the next day.

The **STOIC STOMACH**

To _____,
who certainly drank enough to vomit but held it together.

THE TACTFUL TEXTER

To _____,
who refrained from drunk dialing and texting for an entire night.

(AKA DEN MOTHER)
SCOUT LEADER

To _____,
who prevented us from "buddying up" with the wrong people.

PICK-UP LINE SURVIVAL KIT

A cheat sheet of rebuttals for the most common pick-up lines.

THEM: DID IT HURT?

YOU: What?

THEM: WHEN YOU FELL FROM HEAVEN?

REBUTTAL: Did it hurt when your mom dropped you on your head?

THEM: I LOST MY NUMBER, CAN I HAVE YOURS?

REBUTTAL: Did you lose your sense of dignity too?

THEM: IS IT HOT IN HERE OR IS IT JUST YOU?

REBUTTAL: Is it dim in here or is it just you?

THEM: IF I COULD REARRANGE THE ALPHABET, I WOULD PUT U AND I TOGETHER.

REBUTTAL: That reminds me; I'm just getting over a UTI.

THEM: POLAR BEAR.

YOU: What?

THEM: ANYTHING TO BREAK THE ICE!

REBUTTAL: I'm a climate change specialist for Greenpeace, jerk.

DRUNK CONNECT THE DOTS

How far did you get with this activity (and how drunk are you)?

MADD* LIB(ATIONS)

Create a drinking song to annoy your designated driver. Fill in the blanks with the suggestions below, and sing the words to the tune of "What'll We Do with a Drunken Sailor." Carry this song on for several rounds by customizing it for each of your friends.

1. NAME OF SOMEONE IN YOUR GROUP: _____

2. BODY PART: _____

3. SINGULAR NOUN: _____

4. NON-GEOGRAPHIC LOCATION: _____

5. SOMEONE THIS PERSON HAS A CRUSH ON: _____

*Not actually endorsed by MADD (Mothers Against Drunk Driving) but for the record, we endorse them.

WHAT'LL WE DO WITH A DRUNKEN (1) _____
WHAT'LL WE DO WITH A DRUNKEN (1) _____,
WHAT'LL WE DO WITH A DRUNKEN (1) _____.
WHAT'LL WE DO WITH A DRUNKEN (1) _____,
EARL-AYE IN THE MORNING?

SHAVE HIS (2) _____ WITH A RUSTY (3) _____
SHAVE HIS (2) _____ WITH A RUSTY (3) _____
SHAVE HIS (2) _____ WITH A RUSTY (3) _____
EARL-AYE IN THE MORNING?

PUT HIM IN THE (4) _____ TILL HE'S SOBER
PUT HIM IN THE (4) _____ TILL HE'S SOBER
PUT HIM IN THE (4) _____ TILL HE'S SOBER
EARL-AYE IN THE MORNING?

PUT HIM IN BED WITH (5) _____
PUT HIM IN BED WITH (5) _____
PUT HIM IN BED WITH (5) _____
EARL-AYE IN THE MORNING?

INTERPRET THIS MESS

- The TOP of the page is your PAST, the MIDDLE of the page is your PRESENT, and the BOTTOM of the page is your FUTURE.

- Note carefully the SHAPES created by the wine. Turn the page and view from different angles until the symbols become clear.

- Note their relative size and distance to one another. Side-by-side symbols are connected to each other. Larger shapes should play a more dominant role in your interpretation than the smaller ones.

- Also look for shapes that resemble LETTERS. They may be the initials of someone who is or will be important to you.

EXAMPLE: You see a large serpent at the top of the page, a small heart in the middle, and a letter "C" toward the bottom of the page.

INTERPRETATION: Serpents are always bad luck, but, fortunately, this symbol is in your past. The heart symbol in your present suggests the possibility of a new love interest—but note the small size and don't expect too much. Perhaps this mysterious "C" is the one?

KEY SYMBOLS:

CROWN: expect honors

SERPENT: temptation, distraction, bad luck

BIRD: good news is on the way

LINE: a journey (small line is a short trip, long line is long one, etc.)

DOTS: money

HEART: a lover

STARS: success

OWL: sickness or poverty

ELEPHANT: good health

CAT: an act of deceit

DOG: an act of loyalty

RAVEN: death

APPLE: acquisition of knowledge (or a sweet electronic gadget)

OH, DIVINE WINE

This exercise is like reading tea leaves. Drink almost an entire bottle of red wine. Pour the dregs into a glass, and then fling them across this page.

DEEP THOUGHTS

DRUNK MUSINGS, HALF-REMEMBERED

DRUNK DREAMING

Describe (or draw) a crazy dream that you had after going to bed with your head spinning.

Date: _____

What I was drinking: _____

BLACK OUT

IF YOU REMEMBER ANYTHING AT ALL, WRITE IT IN CHALK OR WHITE CRAYON.

TEN FEET TALL AND BULLET PROOF

DESCRIBE THE MOST INSANE THING YOU'VE EVER DONE UNDER THE INFLUENCE.

Draw of a picture of yourself at the height of your buzz (when you feel the most invincible).

DIARY OF FIRSTS

Take a moment to record your drinking milestones.

1st DRINK EVER: _____

1st IMPRESSION OF BEER: _____

1st IMPRESSION OF WINE: _____

1st BEER/WINE GENUINELY ENJOYED: _____

1st TIME REALLY DRUNK: _____

1st TIME SICK FROM DRINKING: _____

1st TIME PASSED OUT:_____

1st REALLY DRUNKEN ARGUMENT:_____

1st BAR FIGHT:_____

1st MAKEOUT IN A BAR:_____

1st INTOXICATED HOOK-UP:_____

1st TIME TAKING CARE OF A DRUNK FRIEND:_____

GETTING YOUR DRINK ON

SIDE A *UNLEASH THE KRAKEN*

What is your getting-ready-to-party playlist?

SIDE B *HELLO, DARKNESS, MY OLD FRIEND*

What is your wallowing-in-misery playlist?

YOU KNOW WHAT WOULD BE GOOD
RIGHT NOW?

It's 3 a.m. and your stomach is looking for something vaguely more nutritious than booze. Make a list (or doodle) of the foods that you crave:

A tally of snacks to avoid when hammered:

BIG No-No's

PINT HALF EMPTY

Is there a tear in your beer?
Spell out your sorrows here.

PINT HALF FULL

Are you a happy drunk? Jot down anything you're feeling fuzzy about.

 List or draw the things that you've lost while on a bender.*

*NOTE: these lists don't need to be limited to physical items. Friends and ideas can also count.

FOUND

List or draw the things you've discovered under the influence.*

AND FOUND

WISDOM
AT THE BOTTOM OF THE GLASS

No animal ever invented anything so bad as drunkeness— or so good as drink.
—G. K. CHESTERTON

WINE IS BOTTLED POETRY.
—Robert Louis Stevenson

Alcohol may be man's worst enemy, but the Bible says love your enemy.
—Frank Sinatra

ALWAYS DO SOBER WHAT YOU SAID YOU'D DO DRUNK. THAT WILL TEACH YOU TO KEEP YOUR MOUTH SHUT.
—ERNEST HEMINGWAY

Wine is sunlight held together by water.
—GALILEO

Once, during Prohibition, I was forced to live for days on nothing but food and water.
—W. C. FIELDS

The problem with some people is that when they aren't drunk, they're sober.
—WILLIAM BUTLER YEATS

I HAVE TAKEN MORE OUT OF ALCOHOL THAN ALCOHOL HAS TAKEN OUT OF ME.
—WINSTON CHURCHILL

IT TAKES ONLY ONE DRINK TO GET ME DRUNK. THE TROUBLE IS, I CAN'T REMEMBER IF IT'S THE THIRTEENTH OR THE FOURTEENTH.
—GEORGE F. BURNS

SOMETIMES TOO MUCH TO DRINK IS BARELY ENOUGH.
—MARK TWAIN